Charles Harper's Birds & Words

Charles Harper's

Birds & Words

Distributed in the USA and CANADA by Ingram Publisher Services
www.ingrampublisher services.com

Distributed in the UK by ORCA Book Services
www.orcabookservices.co.uk

Library of Congress Control Number: 2008921015

ISBN: 978-193442905-1

PRINTED IN CHINA

To purchase additional copies of BIRDS AND WORDS, or for more information
on AMMO Books, please visit our web site at www.ammobooks.com

For Arthur Lougee, who gave wing to my early birds and words

A Unique View of Nature

What a treasure you are holding in your hands! Welcome to one of the most enchanting nature books in the world. *Birds and Words*, first released in 1972, is a remarkable collection of Cincinnatian Charley Harper's silk-screened imagery that was created for the *Ford Times*, a lifestyle publication from Ford Motor Company. *Ford Times* created an opportunity for Charley to showcase his work, and he produced literally hundreds of paintings and silk screens illustrating the diversity of America and the joys of travel. Charley worked with *Ford Times* for almost 30 years, creating story illustrations of places and people he rarely saw with his own eyes. From the lyrically lined horses at the Sarasota races to the ultra spare dunes of White Sands, New Mexico, Charley's work is undeniable.

For three years in the early 1950s, Charley created six different portfolios of birds that could be ordered from an ad in the back of the February and September issues for 5 dollars a print. The bird portfolios became quite popular and make up the majority of images seen here in the book. The original printing of *Birds and Words* was a modest 2,500 books, making the first printing highly desirable and valuable as Charley autographed almost every copy. Charley designed this book in its entirety, even choosing the fanciful font called "kismet."

Working in a style that he called "minimal realism," Charley distilled his subjects down to its most important core forms, never including anything extra. This singular technique is never more exacting than in the images of his longtime muse, the bird kingdom. Before Charley ever placed paint to canvas, he would painstakingly research his subject matter thoroughly. His tiny studio off the family home he shared with his artist wife Edie and their son Brett was full of all kinds of nature field guides and textbooks. After a full review of every image he could find of his chosen subject, Charley painted the sum of these details since he found that no single image captured all the details fully. Every color he used in his work is exactly the color of its subject.

His devotion to nature was first awoken as a young boy when he noticed a family of water striders gliding along the top of the stream that ran through his family farm. The shadows that danced underneath them on the bottom of the stream inspired Charley's spare and reductive style of painting, a style he continued to develop throughout his 65-year career. As Charley says, "I just count the wings not the feathers."

Todd Oldham
January 2008

8

I Just Count the Wings

When Arthur Lougee, *Ford Times* Art Director in the '50's, asked me to paint some of our feathered friends, I took my first good look at birds as subject matter. I didn't see scapulars, auriculars, primaries, tail coverts, tarsi — none of that. I saw exciting shapes, color combinations, patterns, textures, fascinating behavior and endless possibilities for making interesting pictures. And so I have never counted the feathers in the wings, for that is not what my pictures are about. I just count the wings.

I tried to start off like a good artist-naturalist should, by doing my field work. But I couldn't stalk a bird without stumbling over rocks and snapping dry twigs. By the time I had aimed and focused my binoculars, the bird was long gone. So I bought a bird guide illustrated by Don Eckelberry; it had all the information I needed, and the birds didn't move.

Birds, I quickly noted, possess a built-in functional beauty of form that is imposed by their method of locomotion. In a perched or walking bird there exists a satisfying spatial tension resulting from the heavy body shape supported by unbelievably slender legs. The ratio of mass to support is the secret — the greater the odds, the more gravity is defied, the more potential action is implied in the design. In most other animals (except some insects) this ratio is smaller. If an elephant wore stilts, he'd be as elegant as an egret.

When I am asked to give a name to the way I work, I call it minimal realism. Wildlife art without the fuss and feathers. I don't try to put everything in — I try to leave everything out. I think flat, simple, hard-edge and funny. And I'm probably the only wildlife artist in America who has never been compared to Audubon.

How did it all begin?

Maybe when I was a fledgling. I fell out a second-story window of our nest in West Virginia and hit my head on a stump. Didn't seem to hurt me, so nobody thought much about it until a few years later, when I announced that I wanted to become an artist.

My first esthetic experience occurred in the Sunshine Class of the Frenchton Methodist Church, where my attendance was rewarded with a large picture of a barnyard with a mother hen in the middle and a gummed baby chick to lick and stick on every Sunday I showed up. The sermons didn't make much of an impression on me, but I never forgot the thrill of deciding where to stick the next chick. And I recall long winter evenings, with rain on the roof and wind at the eaves, lying in front of the open fireplace making innumerable cutouts of a flying gull traced from a magazine and arranging ever-changing flocks on a flowered-rug sky. It is a theme that recurs in my work to this day.

Hindsight tells me that I was not exactly your typical American farmboy. I detested the chores—hoeing corn, hauling hay shocks, cutting filth, cleaning the henhouse, stomping down sheep wool inside those big burlap bags on hot summer days. So I goofed off a lot and roamed the hills, especially on hog-butchering and cattle-dehorning days, because I felt sorry for the animals. Even

now, when I pass a truckload of cattle on the way to market, I can't look them in the eye. Before I was old enough to use a gun, a hunter fired over my head at a rabbit and grazed my scalp with a shotgun pellet. I've rooted for the rabbits ever since.

When did I decide to become an artist? When I discovered that I could draw better than anyone else in the fourth grade. In high school I illustrated my homework and salvaged my American History grade by drawing portraits of all the presidents. The lesson was clear: art for fun and profit. I spent a year at West Virginia Wesleyan College, then enrolled in the Cincinnati Art Academy. Before the cultural shock of this move had worn off, I was involved in World War II, ending up in an infantry reconnaissance platoon in Europe. Between mortar barrages, I sketched — that's where I learned to work fast.

I had to try New York, but I got it out of my system fast — one semester at the Art Students League on the crest of the GI Bill Stampede. I lived frugally, ate non-nutritionally, got sick, and felt canceled-out by the manswarm of Manhattan. But I'm glad I did it because now I can say I have suffered for my art. The next year I graduated from the Cincinnati Art Academy, won a traveling scholarship and the hand of Edie Harper, and honeymooned in the Great American West, camping, painting, photographing.

In school I had been painting super-realistically — highlights on hairs. Now I began to feel that this method of dealing with form revealed nothing new about the subject, never challenged the viewer to expand his awareness, denied me the freedom of editorializing. I dealt with the Rockies by walking away from them be-

fore I put brush to paper, eliminating perspective and shading, and recording only what I felt to be their essence. It was the most exciting painting I had ever done; I have never turned back.

Except momentarily, that is, during My War With the Happy Housewife, my epithet for my first year as a commercial artist. I tried my hand at realistic illustration, but it was not to be. I could draw the soap boxes, but not the mindless females holding them. I wanted to fill their vacant faces with wrinkles, crow's feet, double chins — some evidence of humanity. But my only realistic triumph was some cysts for a medical booklet. I did a beautiful cyst. But, alas, there wasn't enough cyst work to keep me busy. To survive, I switched to a stylized, whimsical approach to illustration, based on straight and curved lines executed with T-square, French curve, and ruling pen. I've been doing it ever since.

Ford Times is one of the best clients that ever happened to me because it gave me the opportunity to experiment and develop while working with freedom on a variety of interesting travel and nature subjects. My first silkscreen prints were offered to readers of the magazine — fish designs, Model T's and birds, many of which Ford Motor Company Publications has generously allowed me to reproduce in this book. The editions were small — signed, but not numbered. My friend Ray Podesta helped me with the printing in the beginning and taught me much about the silkscreen process. We started, in those days, with 300 pieces of paper and ended up with as many good prints as providence permitted. It was a basement operation then; now, due to increased production, it is necessary for me to work with a commercial silkscreen shop,

but I still, as always, prepare the stencils, set the registration, check the color, and keep a close watch on print quality.

Did someone ask: what's silkscreening? It's an ancient Oriental process in which a piece of silk cloth is stretched tightly on a wooden frame, a stencil is adhered to the silk, and paint is forced through the openings in the stencil onto the paper by passing a rubber squeege over the silk. Each color requires a separate stencil, and the difficulty of registering the colors with each other multiplies as new colors are added. I have a love-hate relationship with the silkscreen process — hate it because it's so frustrating technically, love it because it gives me the best possible duplication of my work. Because the artist can be directly involved in the process, a silkscreen print provides contact between artist and viewer only slightly less intimate than does the original painting.

By the time I had illustrated *The Golden Book of Biology* and *The Animal Kingdom* for the Golden Press and designed a ceramic tile mural based on American wildlife for the Federal Building in Cincinnati, I knew that I wanted to spend the rest of my life painting nature and that one life wasn't enough time to deal with all the subjects that excited me. My association with the Frame House Gallery gave me, precisely when I was ready for it, the opportunity to concentrate on wildlife art.

Now that ecology is a household word, it is interesting to note how it applies to painting. A picture is a small eco-system that becomes visually self-sustaining when it forms and colors and the tensions they create are combined in a delicately balanced inter-relationship. Some colors gobble up others; overpopulation

by certain shapes can lead to disaster. The joy of making pictures is, for me, the achievement of a satisfying compromise between the ecological truth of the situation I'm depicting and the visual ecology imposed by the picture plane. Learning that my picture has given pleasure to another person — that's a big bonus.

Edie Harper — painter, print maker, photographer, weaver, homemaker, mother — is my best friend and severest critic (her comment on this sentence: I've sure got a lot going for someone who doesn't amount to anything). When I get stuck with a picture, I ask her advice, and occasionally I steal an idea from her (I stole her pig, but she got even — she stole my ladybug). Our son Brett is an English major in college and a silkscreen major at home.

Over the years my field work has improved a little. I can get the bird in the binoculars now, but the more I learn about nature, the more I am troubled by unanswerable questions about human exploitation of plants and animals and our casual assumption that the natural world is here only to serve people. I see all living things as fellow creatures with as much right as I have to be here and to continue living. I have to ask myself how man, the predator with a conscience, can live without carrying a burden of guilt for his existence at the expense of other creatures. Where does one draw the line between preservation of nature and preservation of self? Can a nature lover ever find true happiness at the top of the food chain? If you find humor in my work, it's because I'm laughing to keep from screaming.

Charles Harper

Contents

Ten Western Birds

From *Ford Times*, November, 1956

Mountain Quail

Time bomb of the timeless sierra, the Mountain Quail has a proximity fuse set for three feet. He explodes like a cubist painting of a Mountain Quail exploding, quickening the pulse, rocketing stroboscopically into the chaparral. For him a cliché was coined: "He went thataway." Plumed like a drum major, he avoids parades but dry cleans his uniform and freshens up by taking a dust bath. A family man, he believes in large ones — fifteen, more or less.

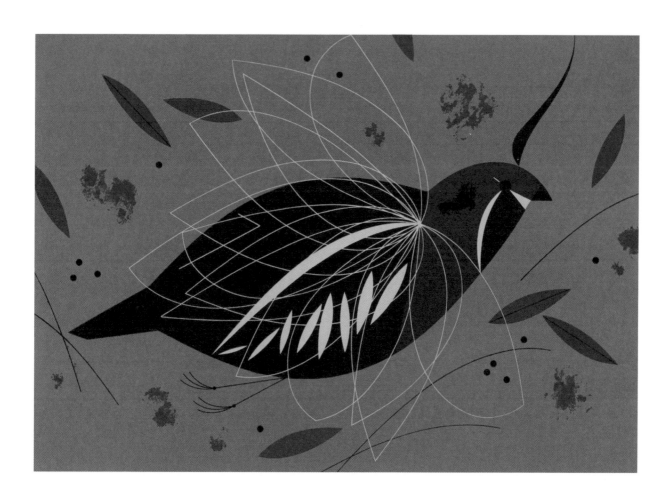

Western Tanager

Bright as a circus poster on a weatherbeaten barn, the Western Tanager looks like a highly embarrassed goldfinch. No tree-top Caruso, he sings for his own enjoyment, telling of far-flung solitudes and the carefree existence, while his wife does the chores. When he visits your fruit orchard, remember that he eats mostly insects, ornaments Christmas trees in July, commemorates in color the autumn leaf, and is what you can say something is not as yellow as.

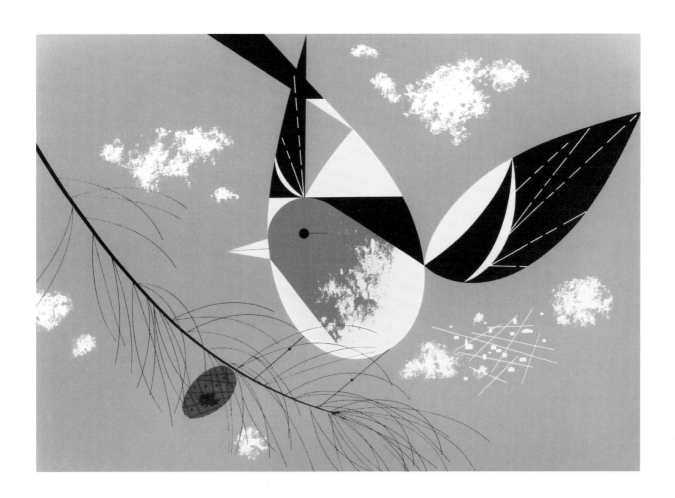

Black-billed Magpie

Gay, braggartly, pilfering, the Magpie is the Capone of the Plains. He puts up a half-bushel, two door, reinforced-mud ranchhouse and has the shortest of widowhoods — up to twenty-four hours. He goes formal to every meal but never bothers to read the menu, being no food snob. From him come the tenderest of filial utterances, but his loud-mouthed yackety-yack in a crowd of male companions is unprintable. He imitates humans — at least, he learns to talk like one.

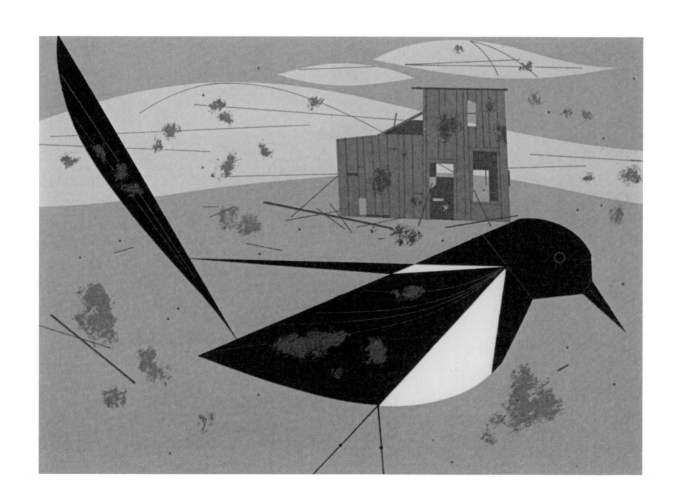

Green Jay

When a stranger comes to town, the Green Jay quickly rounds up a posse to investigate him. Impudent but intelligent, lovely but larcenous, he is loved and loathed, welcomed and rejected. Who's he with — the good guys or the bad guys? It depends on your point of view. If you're a law-abiding citizen whose nest has been looted, you'll arouse the vigilantes and run him out of town. Meanwhile, back at the ranch, his wife is destroying insect pests.

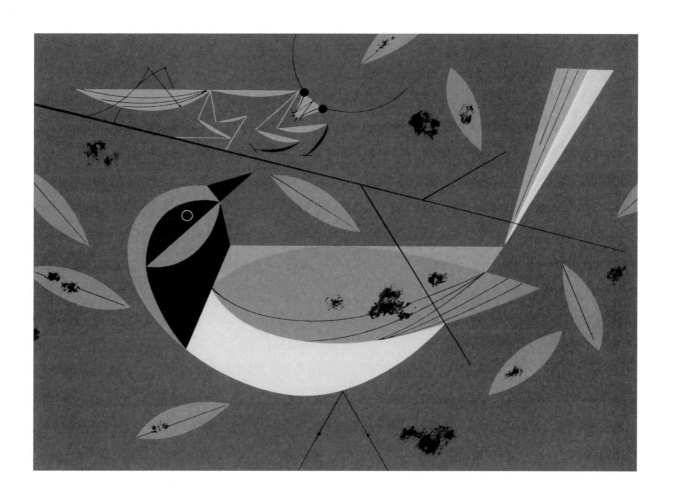

Spotted Towhee

Hail to the clotheshorse of the Underbrush Haberdashery! The Spotted Towhee dresses for a ball, but loses his nerve and stays home. Anyway he'd rather scrounge under sticks and stones for slugs and bugs. He's the bird with the worm's-eye view. Shy, self-conscious, stealthy, this undercover agent always has the drop on you. Ecstasy seizes him occasionally, driving him to drop a syllable from an aspen limb. His answer to all questions is "Yup."

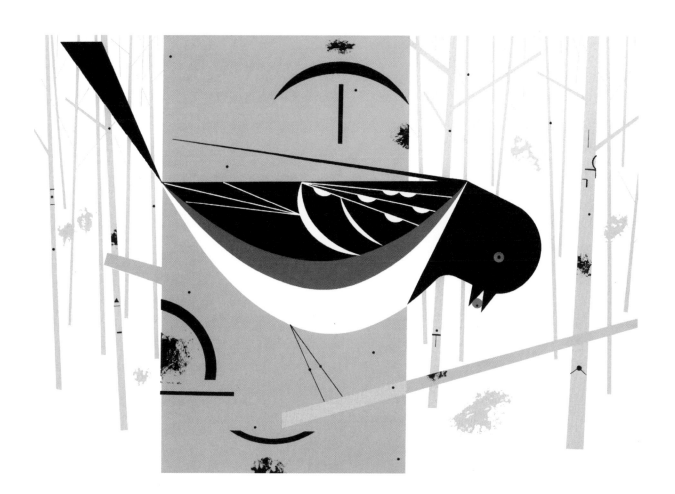

Gray-crowned Rosy Finch

When the Rosy Finch remarks, "Zee-o," as he often does, he has just looked at his thermometer. Admiral Byrd of the birds, he long ago investigated above-timberline opportunities for enterprising finches, found the fierce white world of the eternal snows irresistible. *Leucosticte tephrocotis.* Some call him Loco, but consider for a moment his assets — independence, living room with a view, Mother Nature's Food Plan to keep his deep freeze bulging.

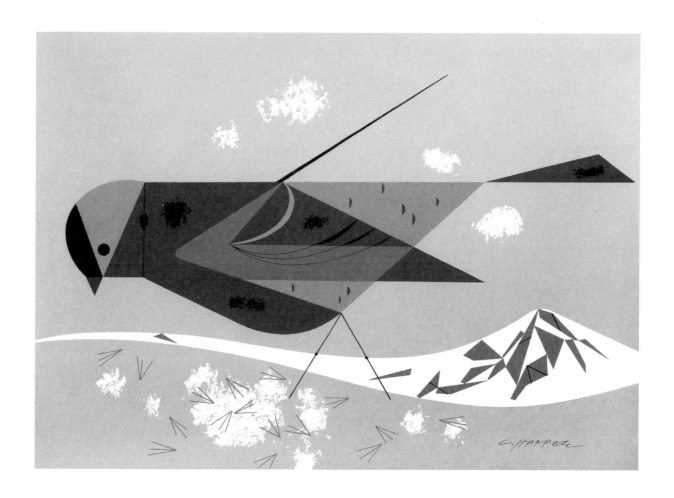

Mountain Bluebird

Turquoise, azure, cerulean — what word does justice to his blue? An ounce of western sky fallen to earth? Like all conscientious bluebirds, he dispels gloom, heralds the good life, and promises the brave new world. Door-to-door salesman of do-it-yourself contentment, and tourist at heart, he peddles his happiness from the Cascades to the Sierra Nevadas, cottonwood grove to timberline, Moosejaw to Eagle Pass — all over his own backyard.

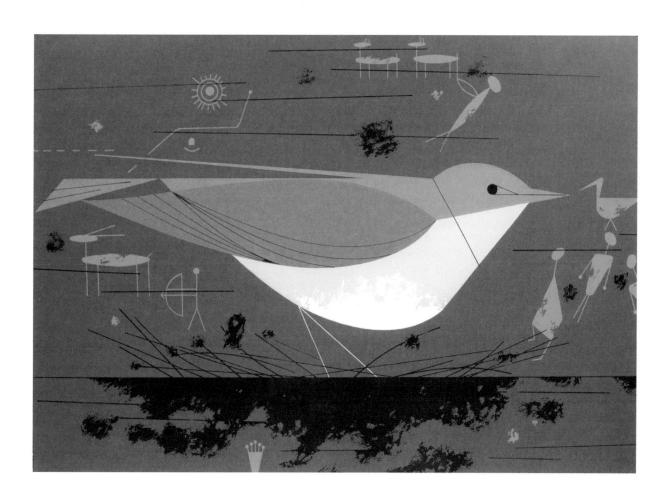

Scissor-Tailed Flycatcher

Vanity, thy name might well be Scissor-tailed Flycatcher! His flight a poem, his train a June bride's dream, his choreography the envy of ballerinas, he is the Texas Bird of Paradise — high praise indeed for any bird this side of it. But he is more interested in law enforcement than looks and elects himself sheriff of the county. He catches more grasshoppers than flies, but who wants to be called a Scissor-tailed Grasshoppercatcher?

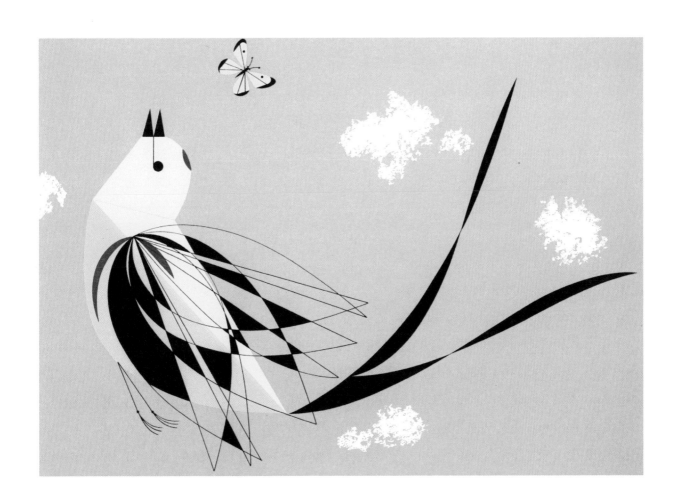

Cactus Wren

When a six-year-old tourist asks, "What for is a cactus?" this wren is your answer. He lives in it. He also lives in the zizyphus bush. A homebody with a passion for real estate, he builds several nests, repairs them constantly, installs wall-to-wall featherbeds and burglar-proofs them with stilettos, ice picks and bayonets. His *chut, chut, chut* is a splash of color on a Dali landscape. Having lived here all his life, he knows a secret way through the pass.

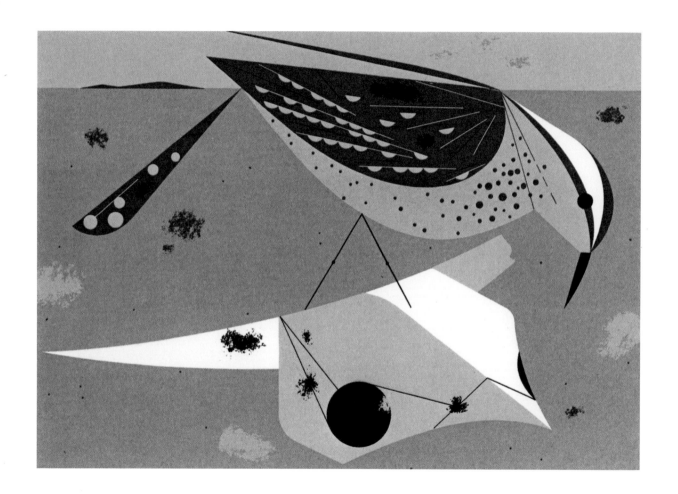

Burrowing Owl

One of nature's drollest creatures, the Burrowing Owl spends each day in pantomiming, "How do you do?" to family, friends, and passers-by, and in eating his weight in things you wouldn't eat your weight in, nor even his. More at home under the range than on it, he knows it's cheaper to board than to build (even if people suspect that you have rattlesnakes) so he redecorates an old gopher hole. He will probably twist his head off if you walk around him enough times.

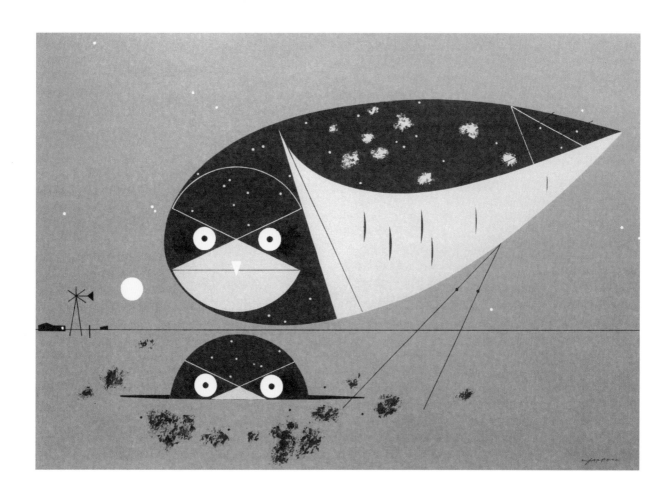

America's Vanishing Birds

From *Ford Times,* November, 1957

Great Auk

The Great Auk swam like a fish, walked like a penguin, and flew like a stone. But he adapted happily to ocean life, prospering from Iceland to Florida, while heading the menus of North Atlantic islanders for three hundred years. Then the professional hunters invaded his nurseries, butchering relentlessly for oil and feathers, encrusting Funk Island with discarded carcasses. The last of the Great Auks was clubbed to death in 1844, heading the obituary column of American birds.

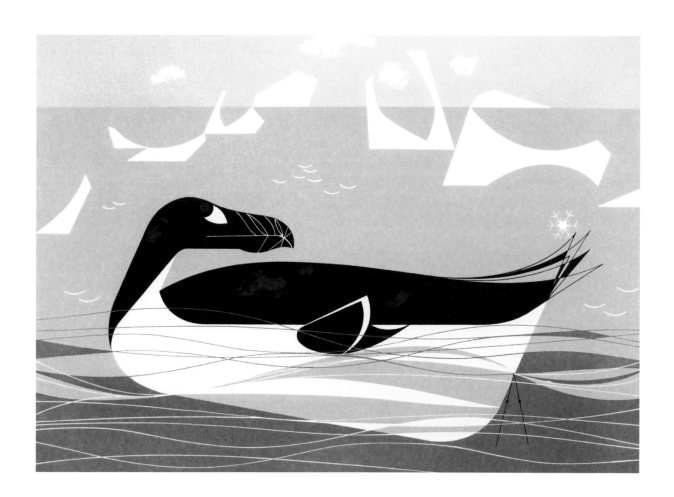

Carolina Paroquet

Once abundant in the southeastern coastal states, the Carolina Paroquet occasionally flashed his tropical colors in the winter-worn North. He was fond of fruits and seeds, a safe diet until the white man planted orchards and grainfields. After that the Paroquet spent his days, which ended in 1904, as a highly visible target. Even when he escaped the farmer's bullets, he fell prey to the cage-bird dealer or the milliner, who catered to the Victorian passion for personal adornment.

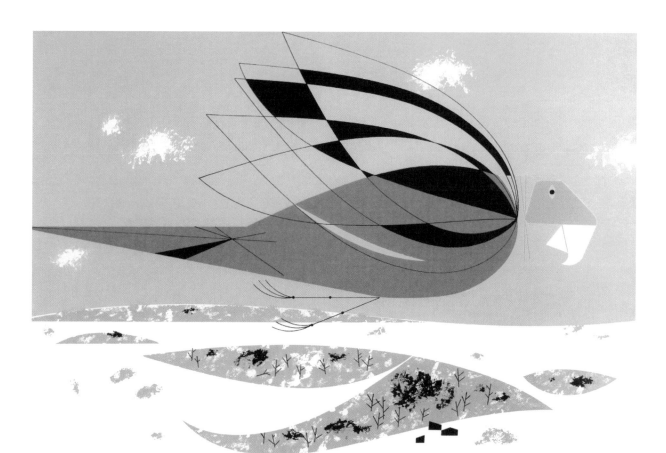

Labrador Duck

The fate of the Labrador Duck is obscure, but it was undoubtedly hastened by egg collectors and by wholesale slaughter for the retail market. During the breeding and moulting season, when he lost the power of flight, his flocks were helpless — sitting ducks for the hunting ships sent north by the feather merchants. The last survivor was shot on Long Island eighty-two years ago, but he is memorialized by forty-four stuffed specimens in museums and by countless antique featherbeds.

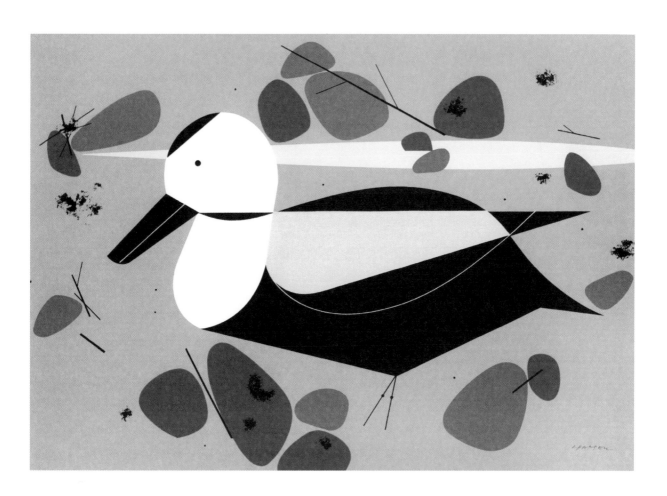

Passenger Pigeon

Plural beyond comprehension, the Passenger Pigeon once swept our skies like feathered flash-floods, eclipsing the sun, staggering the mind, devouring the field, glutting the Eastern woodland with his chaotic tree-tenements. But by 1914 he had vanished. Gentle and trusting, he found no safety in numbers; where he paused to feed, the countryside feasted and pigeoners prospered. The leftover corpses, streamlined and iridescent, were used to fatten hogs and fill mudholes, or left to rot.

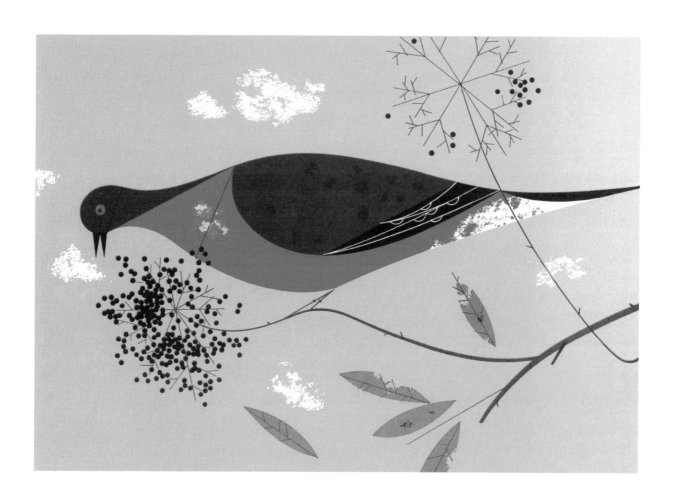

Eskimo Curlew

In autumn the Eskimo Curlew fueled up on berries and snails and flew the Atlantic non-stop, from the New England Coast to South America; in spring the breeding instinct drew him back to the Barren Grounds of Canada via the Mississippi Flyway, where he refueled on insect pests. Both ways he ran the gauntlet of a hunter army, which stalked him from state to state to provision meat counters by the wagonload. One hunter downed 28 Curlews with a single blast to become the 20th Century's Man of Extinction.

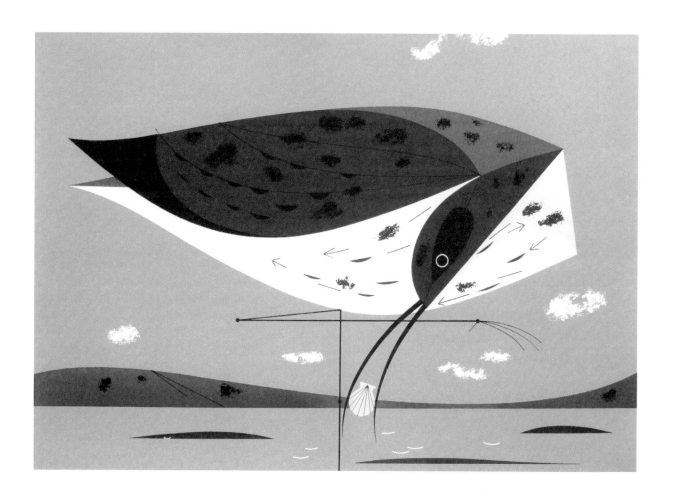

Heath Hen

He wore the uniform of the Prairie Chicken, but this was a different drummer. The east coast was his booming ground, and he was so common around Boston in the 1830's that appetites jaded on Heath Hen drumsticks. A century later, cornered on Martha's Vineyard by proliferating people pressure, his band vanished. The last Heath Hen was the first last of a species to be studied in his natural environment, one of our most famous last birds.

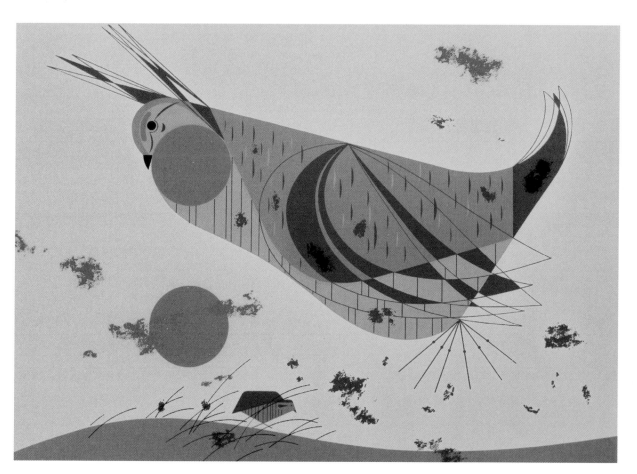

Ivory-billed Woodpecker

A hermit by temperament and largest of our Woodpeckers, the Ivory-billed dines on woodborers beneath the bark of deceased and dying trees in southern cypress swamps. Indians treasured his bills as amulets and sought to attain his courage vicariously by collecting them in quantity. White men furthered his demise by shooting him for food. But the lumbermen made the Ivory-Bill's extinction highly probable by felling the ancient forests, thus destroying his privacy and his pantry.

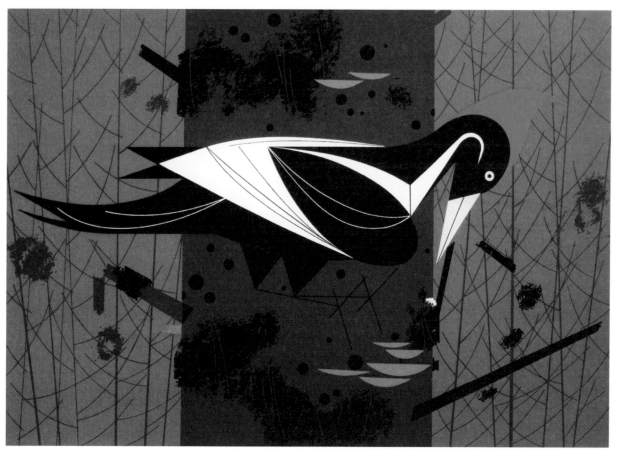

Whooping Crane

Tallest of American wading birds, the Whooping Crane rears his family in a remote part of Northern Canada, and winters in Aransas National Wildlife Refuge on the Texas coast. Our forefathers saw him in New England and the East, and, although he flew at great heights, his Mississippi Valley migrations were awesome to experience. But the Whooper Rating is currently so low, in spite of his national publicity, that there is anxious speculation about his return in the fall.

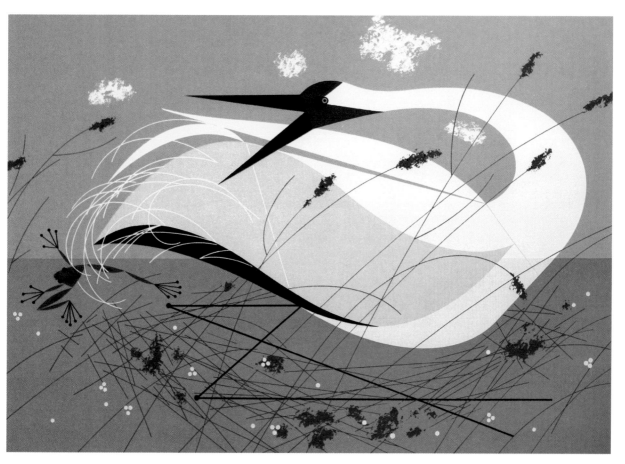

Trumpeter Swan

In the twenties, the Trumpeter's swan song was heard across the land; civilization had driven him to the verge of exinction. But he made a comeback by going into isolation in the wilderness fastnesses of the Northwest. Now he nests safely on a remodeled beaver lodge in Red Rock Lakes National Wildlife Refuge, Montana. But his great size and beauty are still a temptation to marksmen eager to prove their skill on anything that moves, the bigger the better.

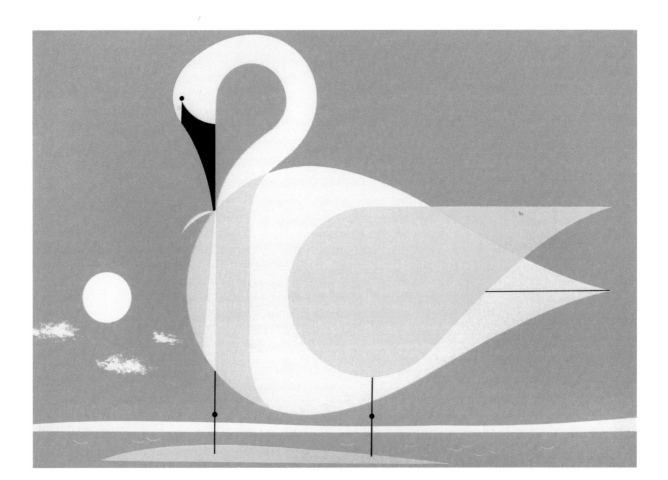

Everglade Kite

The Everglade Kite ranges from South America to Florida, but he may soon be lost to us. On whispering wings he rides the marsh thermal at grasstop level, searching for his only source of nourishment, the fresh-water snail *Ampullaria*. The snail has problems, too: as men drain the marshes his habitat vanishes, and so does he. This fact now confines our Everglade Kites to Lake Okeechobee where if starvation doesn't get them, poachers probably will.

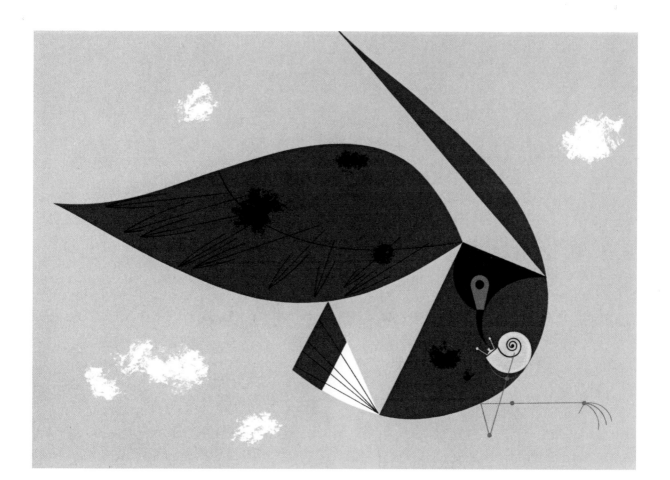

California Condor

Like the Burying Beetle and the Vulture, the California Condor works at preserving our country's fragrance, while utilizing the dead in the cycle of life. But when the news got out, around 1900, that our largest bird was scarce, collectors made him scarcer. Others killed him merely for pastime. Aerodynamic poet laureate and one-time coast-to-coast traveler, he is now confined to Sespe Wildlife Reserve near Los Angeles, where about sixty Condors are carefully protected from civilization.

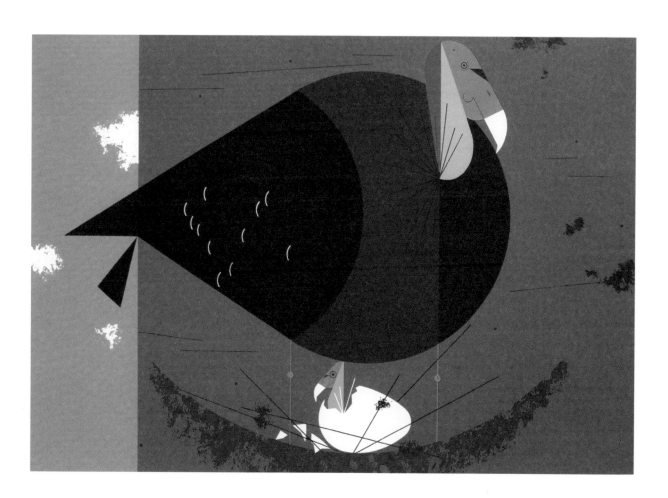

Ten

Southern

Birds

From *Ford Times,* November, 1958

Swallow-tailed Kite

Countdown starts at dawn for the Swallow-tailed Kite, America's most graceful flier. Orbiting over the marshland, he keeps close tabs on the comings and goings of snakes, lizards and frogs, which constitute his breakfast. Occasionally, too, he plucks a newly-hatched alligator from this planet. He is wise to spend most of his life in space because Earthmen usually greet him as they might a visitor from Mars — shoot first, ask questions later.

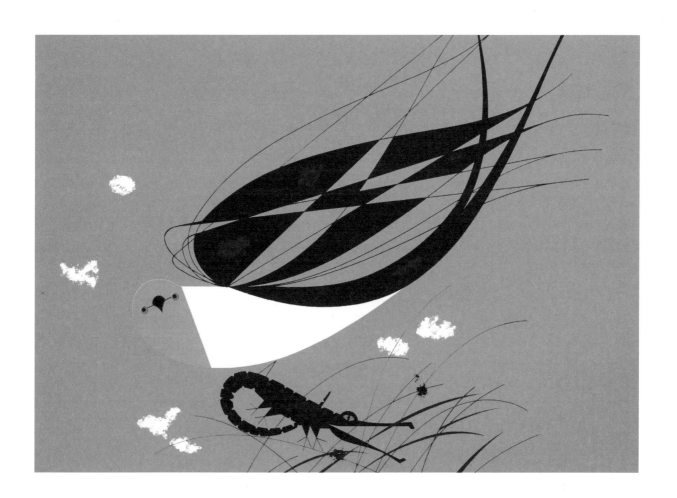

Painted Bunting

The Painted Bunting is in advertising — direct male advertising, that is. While his conservative wife remains in the background, he is busy in garden, hedgerow and thicket, proclaiming himself in glorious Technicolor and singing commercial, *pew-eta, pew-eta, I eaty you too.* Quick to anger and mighty in combat, he will fight to the finish for home, mate and the joy of conquest. Once a victim of cage-bird dealers, he was known in the marketplace as "Nonpareil" — without an equal.

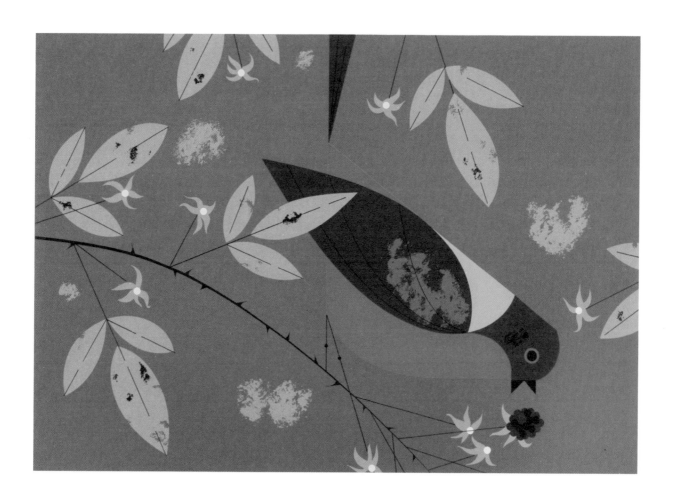

Flamingo

Of the millions of Flamingos in America today, only a handful are alive. The rest are front-lawn effigies, proclaiming to all passers-by our national love for beauty. Countless businesses commemorate the name, too — sixty-one in Miami alone, including the Flamingo Canine Beauty Shop. Never a native of our shores, he visits them only rarely today, a prudent precaution since his forefathers were massacred here by beauty lovers of an earlier generation.

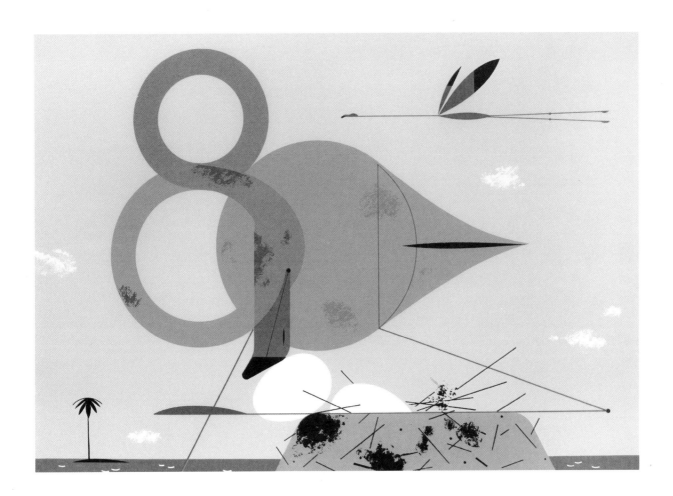

Purple Gallinule

The Purple Gallinule is the poor man's peacock, the Pavlova of the pond. One of our most exquisite water birds, in costume and choreography he animates marshes and roadside ditches all over Dixie. *"Hiddy-hiddy-hiddy, hit-up, hit-up, hit-up,"* he comments as he closes in on his dinner, using the lilypads as stepping stones. When he's in a hurry, though, he flies. But he apparently places little faith in air travel as he never retracts his landing gear.

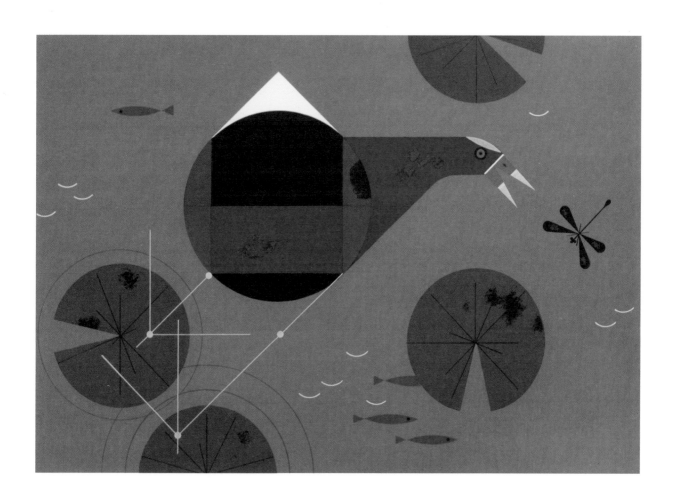

Water Turkey

The Water Turkey lunches and launders at the same time, then returns to his favorite perch and hangs his wings out to dry. Somber and silent, resembling a cormorant and looking not a bit like a turkey, he haunts the cypress lagoon like a ghost in a gloomy castle. Is he bird or reptile? He flies like a bird, but swims like a snake, with only his head above water. It is easy to imagine that he consorts with the dinosaurs in some yet-to-be-discovered expanse of steaming prehistoric jungle.

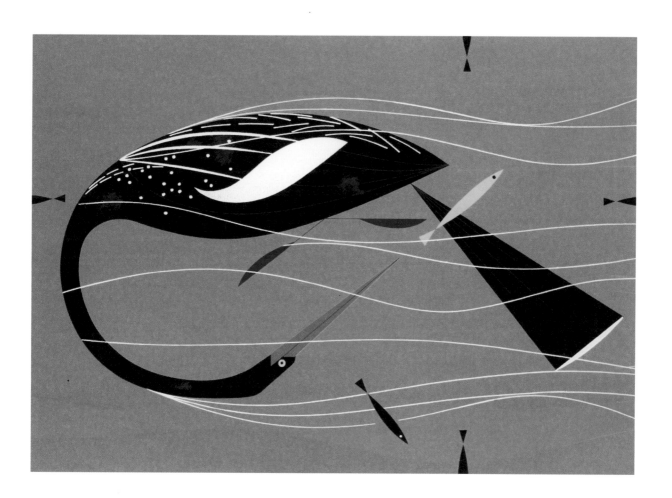

Mockingbird

Some birds have all the talent. Take the Mockingbird, for example. Mimic, composer, arranger, vocalist, clown, he still finds time to devote to his family. Like many another life-of-the-party, he gets his kicks by recording everything that happens and playing it back for all to hear, hi-fi and unedited. Thus his moonlight sonata is likely to be punctuated by variations on a theme from a power mower and Mrs. Catbird's conversation with Mr. Wren.

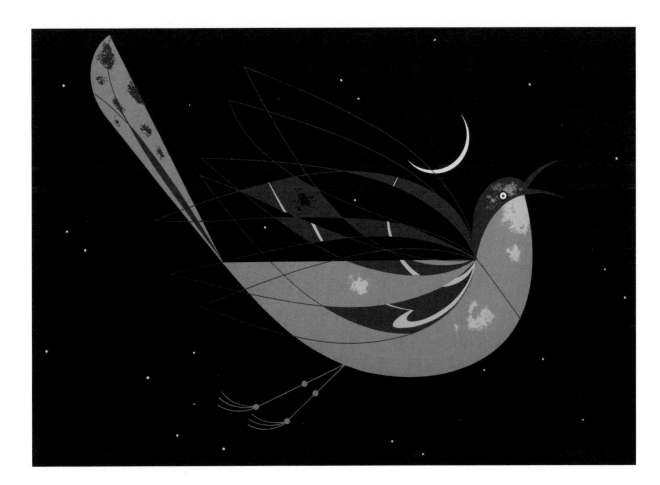

Snowy Egret

The Snowy Egret wears a silky white wedding gown with a long lace train and pledges his troth with a twig. She does, too — and it's a double twig ceremony. But who can tell the bride from the groom? They can, and a few weeks later they're taking turns at babysitting, keeping their love alive by swapping twigs at nest-relief. The Snowy's recovery from near-annihilation by plume hunters is one of our country's happiest examples of conservation in action.

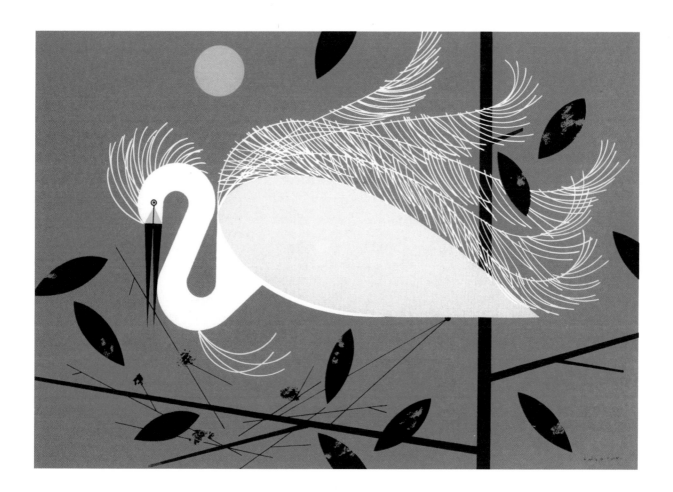

Wood Ibis

The Wood Ibis is our only native stork, but he does not, as you might suppose, hang around obstetricians' offices. He hangs around swamps instead, where, from his cypress maternity ward, arises a cacophonous chorus of grunts, croaks and squeals suggesting that he is too busy with his own domestic difficulties to run a delivery service on the side. Sometimes, just to get away from it all, he rides a thermal to dizzy heights. He can also fly upside down.

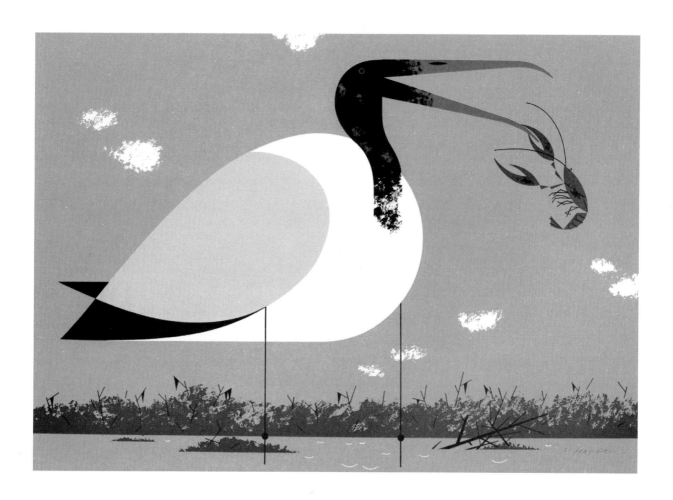

Limpkin

Because he walks with a slight limp, the Limpkin is called the Limpkin. This does not mean that he is crippled, however, as all Limpkins limp. But for some reason he is not satisfied with his lot in life, so he broadcasts his banshee wail of woe to the marsh-world in the still of the night. This has earned him a reputation as "the crying bird." He is also a noted gourmet; a pile of empty apple snail shells identifies his favorite dining-out spot.

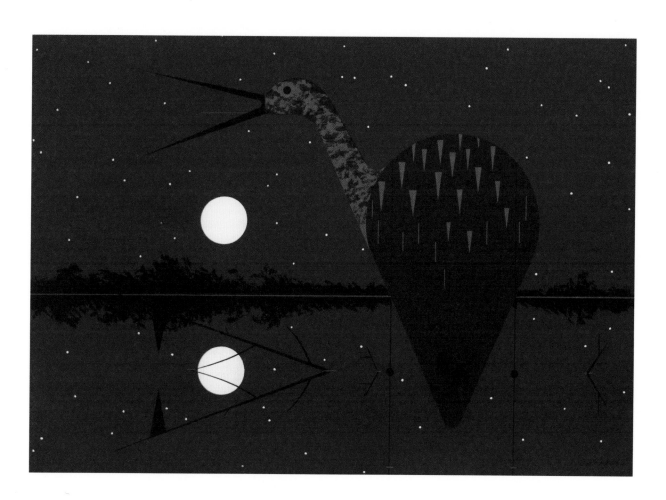

Roseate Spoonbill

Don't be offended if this bird looks down his nose at you — he was born with his mouth in a silver spoon. The Roseate Spoonbill's beak is a special attachment with which he dredges aquatic goodies out of the mud. For after-dinner relaxation he stands on one foot for an hour or more. The Spoonbill was once numerous on the Florida and Texas coasts, but by 1920 was more frequently seen on ladies' bonnets and souvenir fans. His future is still uncertain.

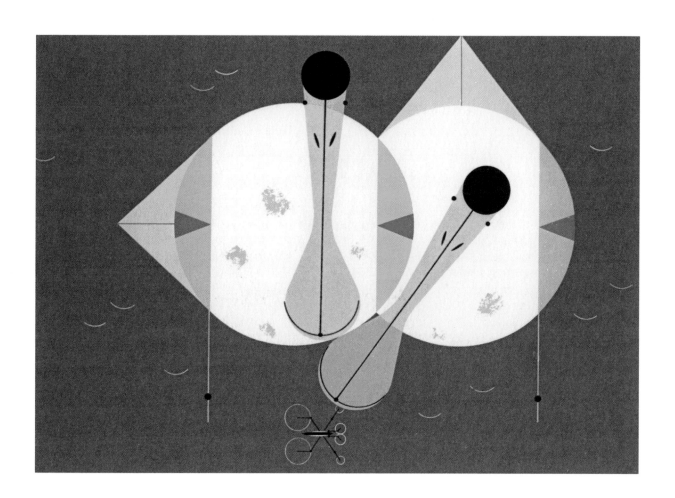

American Bird Architects

From *Ford Times*, November, 1959

Baltimore Oriole

Of all bird architects, the Baltimore Oriole seems most aware that form follows function and that bird nests are for birds. Her classic pendulus nest is formed with sensitive engineering and flawless weaving. It's the Nest of the Year, year after year. On a warp of flexible bark fibers attached to the tips of high branches, she looms a bag of grass, horsehair and string. And when the wind blows, the cradle does rock.

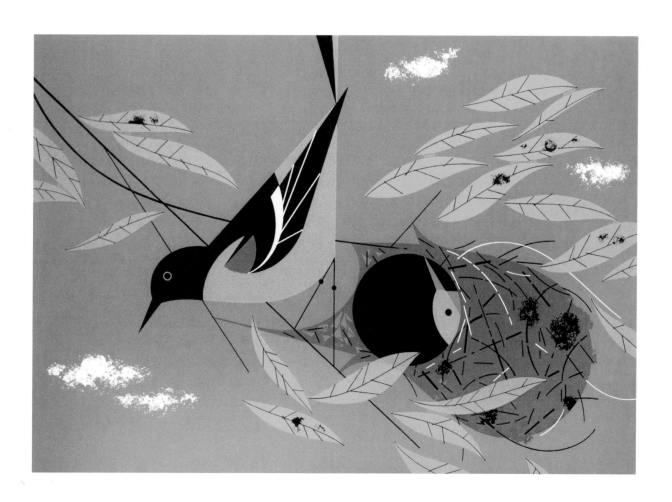

Bank Swallow

Dig this crazy architecture! Bank Swallows nest in cooperative apartments with sieve-like facades, excavated with beak and claw in the clay or sand of river banks, gravel pits, highway cuts and sawdust heaps. At the end of a 2- to 4-foot hallway, they place the family room, wall-to-walled with feathers and grass. Utilities? They eat, drink and bathe on the wing. But how do they know which hole to come home to?

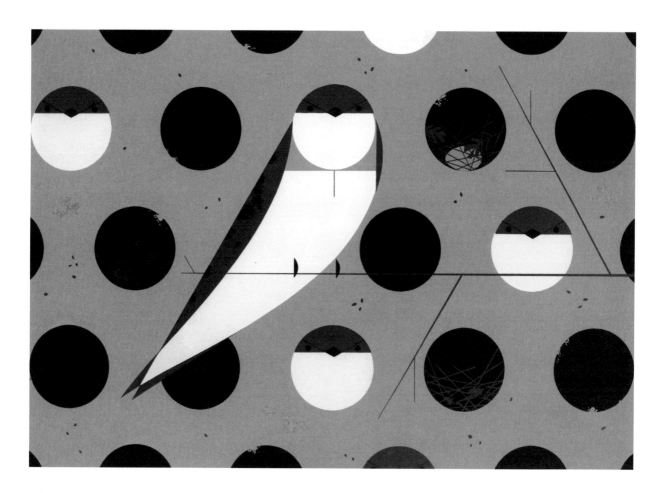

Ruby-throated Hummingbird

Hummers can fly backward, vertically and pause in midair. This is handy when you do your housebuilding in a tree. Mr. Ruby-throat checks out after the honeymoon and something tells Mrs. to start building the tiny attached-saddled nest, glued by salivary secretion to a down-sloping branch. It's made of plant down, lichens, and silk borrowed from a neighboring spider, whom she later has over for dinner — hers.

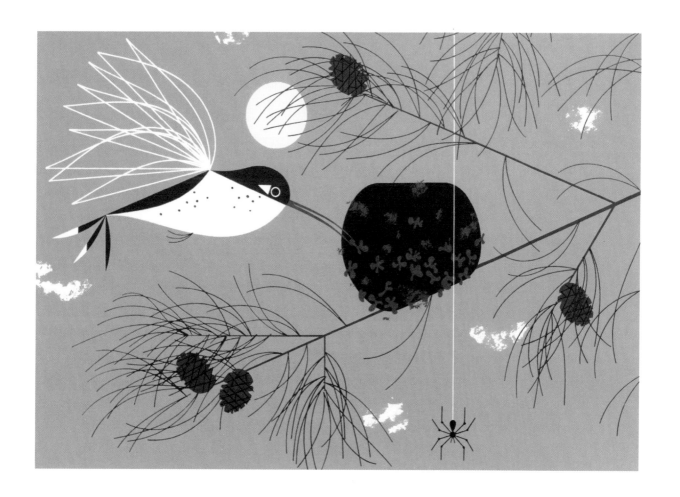

Barn Swallow

No barn is complete without Barn Swallows. Commuting jet-like from hayloft "subirdia" to work in the meadow, they distribute good cheer in the barnyard and bad news to flying insects. Expert masons, they mix mud and straw for their pendant, cup-shaped nests stuck to upright timbers and lined with feathers from local leghorns. Long ago they deserted the caves; now no Barn Swallow is complete without a barn.

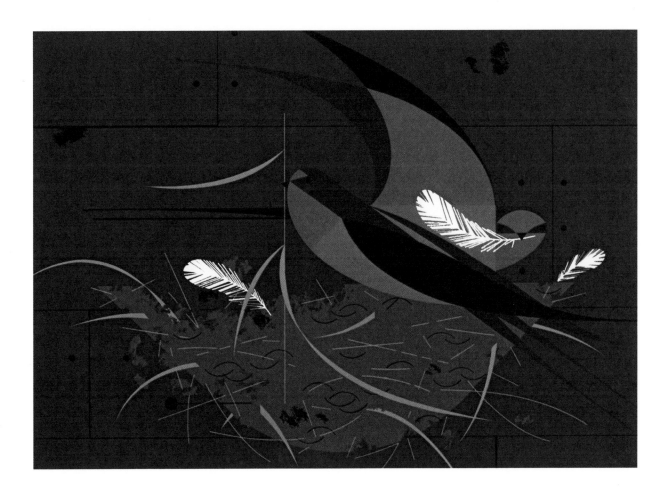

House Wren

If House Wrens were people, they would probably remodel old farm-houses. But they're not, so they remodel other things, like old shoes, tin cans, cows' skulls and clothespin bags, using twigs, grass, feathers, bark and spider webs. He stakes off the lot and fills some holes with sticks. She decides which one they'll call home, throws out all his furniture, and starts from scratch. Maybe House Wrens *are* people.

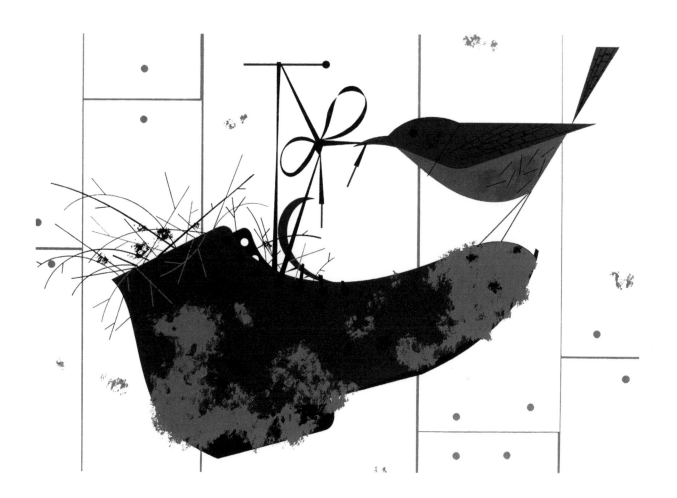

Rose-breasted Grosbeak

For all his rakish good looks, the daddy Rose-breasted is the very model of the family man. He helps assemble the platform-standing nest of twigs, stems, grass and rootlets, then cheerfully relieves his drab little mate on the nest, humming a housewifely tune as he incubates. To the kids, he is hero and pal. And he seldom returns from a trip without some thoughtful little remembrance, such as a potato bug.

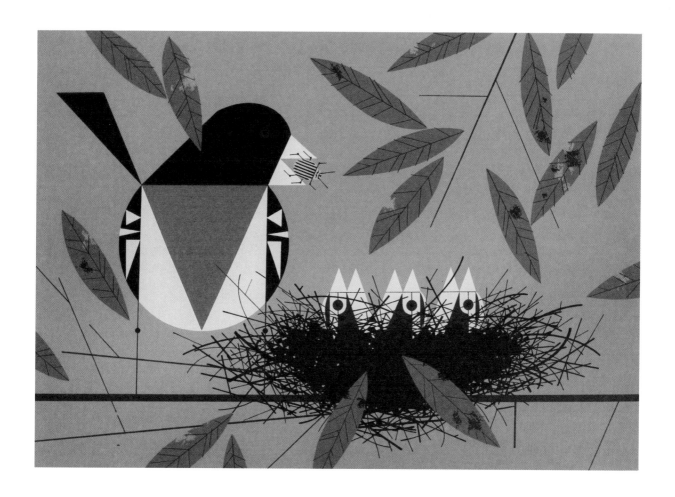

Indigo Bunting

The Indigo Bunting is a proud papa. As soon as the nest is built —
a compact cup of grass and leaves, attached and standing in the
upright crotch of a shrub — he starts proclaiming the blessed
event from the treetops. He has even been known to take a turn
on the eggs. His mate — what did he ever see in her? Dull and
anonymous, she'd never be noticed in a crowd of sparrows. But he
is faithful to the end — of the summer.

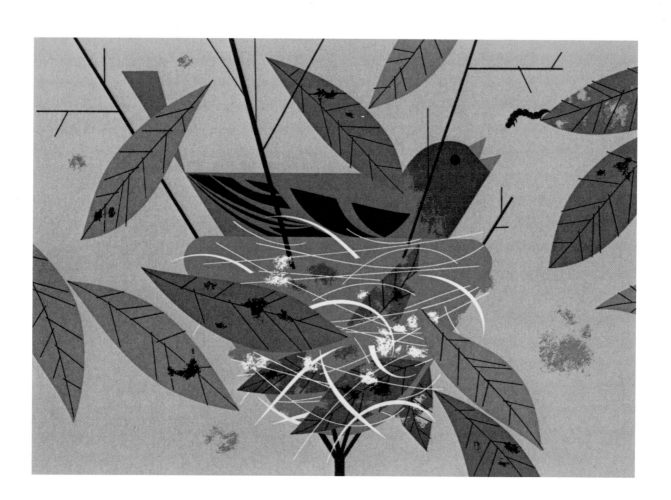

Horned Grebe

The Horned Grebe summers on the lake, where she builds a floating platform of mud and porous, air-filled vegetation, docks it like a shanty-boat among the reeds, and deposits 3 to 7 eggs. They are never dry, but their chalky shells exclude moisture and the decaying nest probably generates heat to help them hatch. The chicks are natural-born swimmers, but they shouldn't go near the shore until they learn to walk.

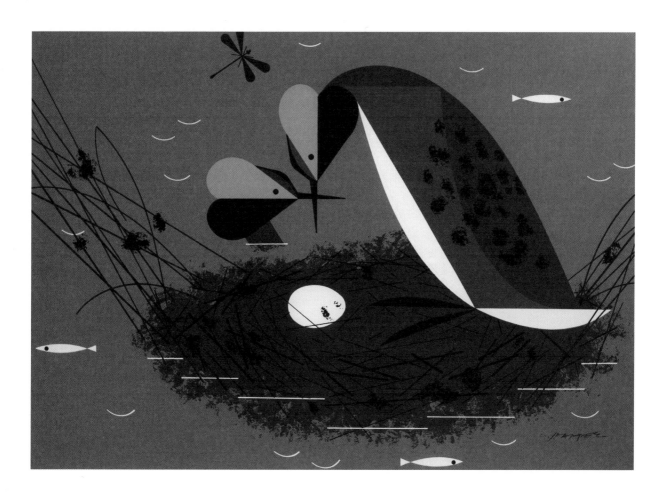

Red-eyed Vireo

Like many a do-it-yourself homebuilder before them, these Red-eyed Vireos had to move in before it was finished. Common delays: too much rain and hard-to-get materials, which they often airlift from long distances. Their semi-pensile nest, a cup of expertly woven plant fibers hung from a fork in a branch, is decorated with cocoons, bark, newspaper and hornet nest scraps — all find-it-yourself materials.

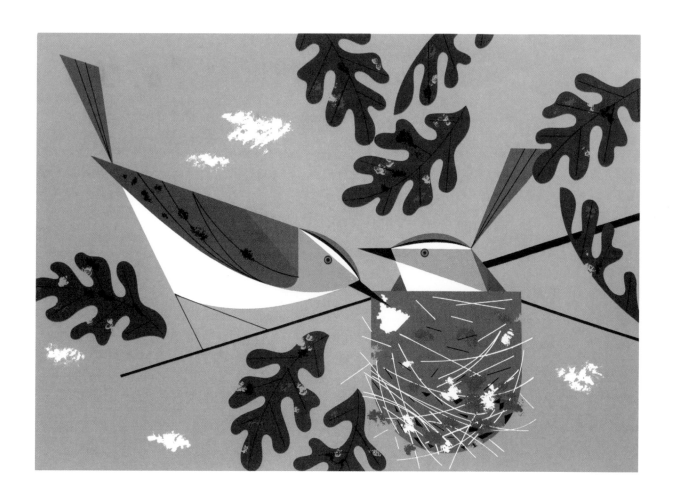

Eastern Meadowlark

A bird's-eye-view of the Meadowlark's nest reveals nothing. In the dark green world at the bottom of the meadow, she fashions an arched-over cup of dead grass which she enters like an oven. Carrying the camouflage further, she establishes landing strips away from the nest and approaches it on foot. It's a desirable location: quiet country living with city convenience — just a step from Mother Nature's Supermarket.

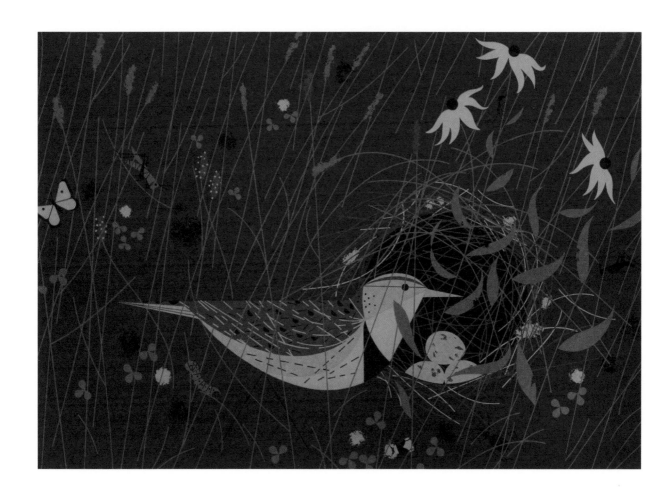

American Bird Census

From *Ford Times*, November, 1960

Red-winged Blackbird

If Blackbirds *were* made into pies, the Red-wing would fill every pastry shop from coast to coast, for he is probably our most numerous bird species. This is less surprising when you consider that he practices polygamy. A 1959 Christmas Count group in Norfolk County, Virginia, recorded eight million Red-wings, the greatest number of individuals of any species found in any fifteen-mile-wide pie in America.

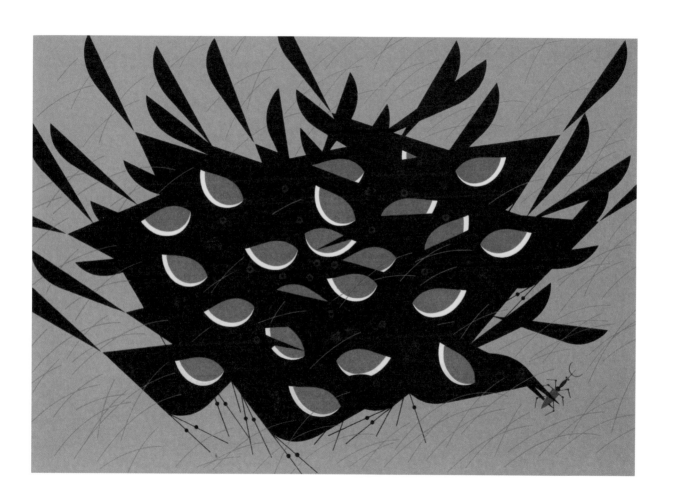

Murre

It's Standing Room Only at Three Arch Rocks, America's most densely settled bird colony, off the Oregon coast. Here 750,000 Murres practice togetherness on seventeen acres, roughly a square foot for every citizen, except the ones on the outside edge. Murres incubate in a standing position and their eggs are top-shaped which prevents them from rolling, which is lucky because — *oops,* look out below!

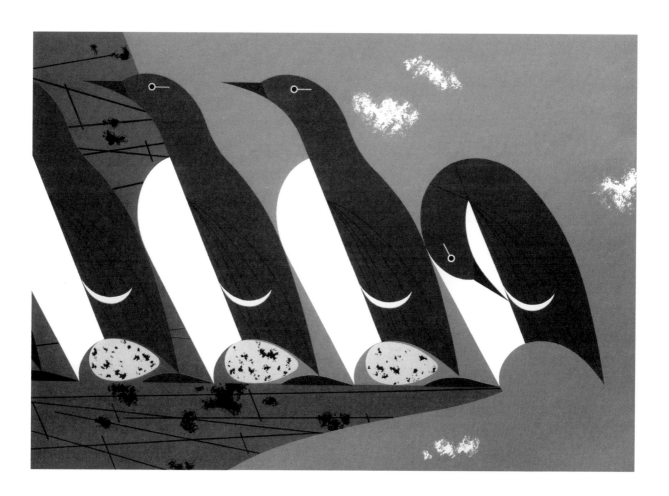

Snowy Owl

One Snowy Owl is enough to make any Christmas Count memorable because he is only a tourist in these parts, visiting us as a winter erratic. But his visits are more like invasions about every four years, the Count shows, when his dispersal cycle peaks as the Artic lemming population ebbs and hunger drives him southward. Warning to American mice: stay indoors in 1960, the golden-eyed ghost is coming.

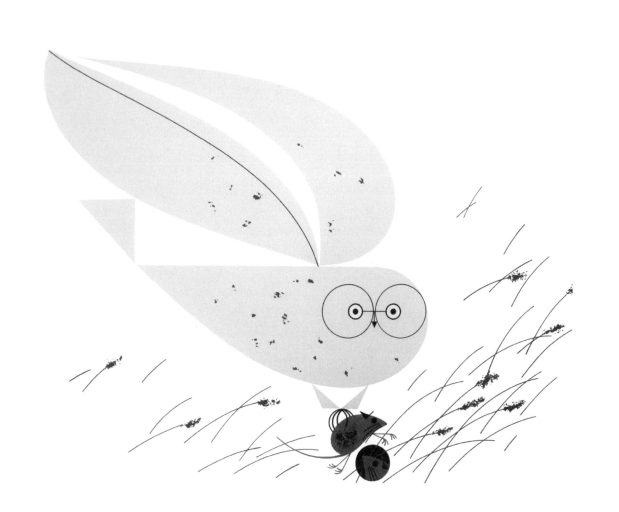

Cardinal

A Cardinal adds his blazing exclamation point at the end of a fresh snowfall. The Christmas Count reveals that this scene is becoming increasingly common because the Cardinal is expanding his range northward, apparently to relieve Red-bird population pressure in the South. Sunflower seed will keep him coming to your feeding station. Excuse the napkin under the chin — no lap.

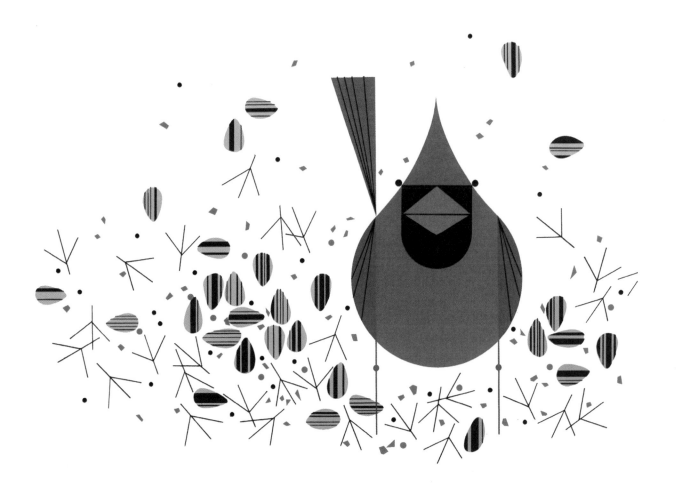

Eastern Kingbird

The Kingbird is one of the Tyrant Flycatchers, *Tyrannidae* — America's largest bird family — 365 different species. But this feathered gadfly is less a tyrant than a foe of tyranny, for he strikes like a guided missile at any larger winged creature that violates his airspace. Hawks, crows, owls, vultures, even eagles — all have played Goliath to his David, and he protects many a chicken-yard from surprise attack.

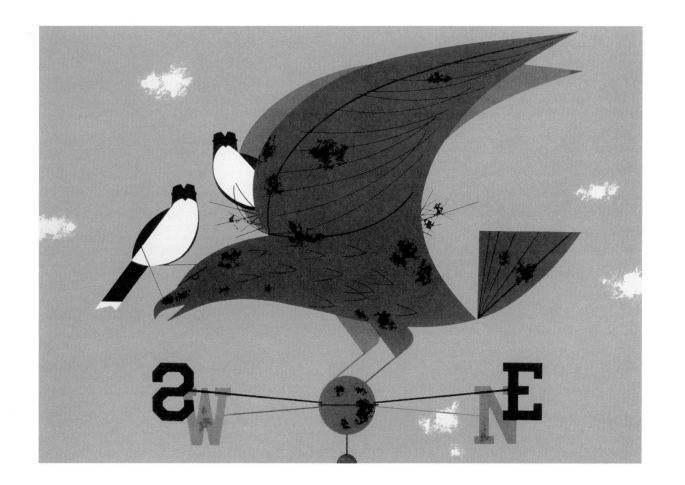

Starling

Talk about a population explosion! The Starling's count has mushroomed yearly since he was brought from Europe in 1890. This bird is giving people their comeuppance — each winter his squadrons invade more of *their* habitat. They retaliate with such ultimate weapons as stuffed owls, Roman candles, supersonic whistles, and cat-faced balloons, but *he's* winning the Starling War.

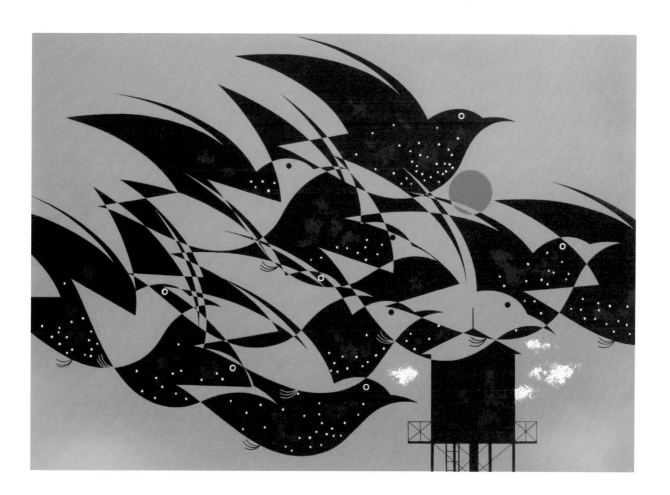

Wood Duck

A continuing census of both ducks and duck hunters is carried on by the U.S. Fish and Wildlife Service for the purpose of regulating open seasons and bag limits. Thus the jewel-like Wood Duck, once nearly extinct, was saved from extermination by hunters. But what will happen when the proliferating human population invades the last remaining acres of his habitat? Wood Duck Acres.

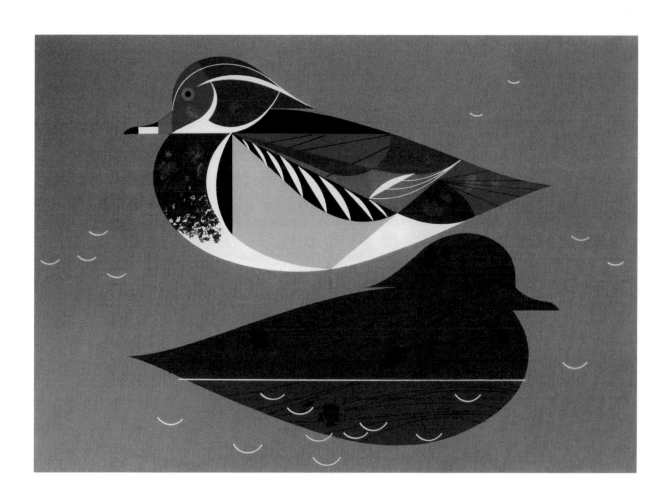

Blackburnian Warbler

The Blackburnian shouts, "Here am I — count me." He is one of Nature's specific statements, never to be dismissed as "some kind of a warbler." Fifty-three other species of warblers swell the migrant waves that engulf the eastern flyways. Traveling under cover of darkness, they are seen through telescopes as silhouettes passing the full moon or on radar screens as blips that pass in the night.

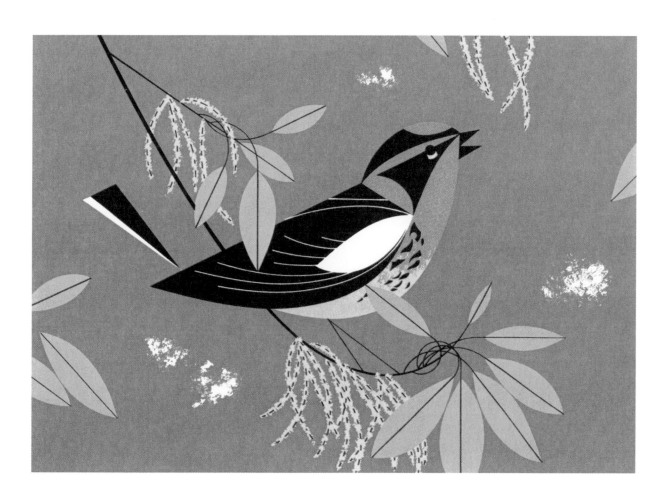

Ptarmigan

Puzzle for bird counters, and everybody else—find the Ptarmigan. White-on-white in winter, brown-on-brown in summer, he spends his life above timberline in the Cascades and Rockies. But near perfect concealment does not save him from a rhythmic rise and fall in numbers revealed by counts of non-migrating populations. The cause of the several-year cycle is still black-on-black.

Wood Thrush

At nesting time, the daddy Wood Thrush vocalizes his territorial claim, and the census taker assumes that he speaks for one Wood Thrush family. By employing this song-counting technique to survey other species, the Breeding-Bird Census has produced these birds-per-acre averages: 9.4 in marshes, 4 in deciduous woodland, 2.25 in farm country, 0 in Bonneville Flats, Utah.

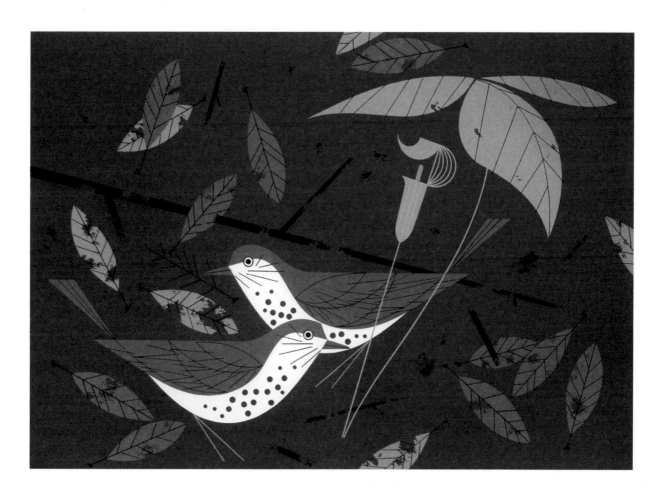

Ten

Collector

Prints

From Frame House Gallery Serigraph Series

Barn Owl and Harvest Mouse

The Barn Owl wears a valentine for a face, but he never sends it — he brings it. And, like all small creatures of the night, the Harvest Mouse knows well the message that comes with it: BE MINE. The owl-mouse affair has been going on for so long that it is one of the classic examples of the enforcement of nature's unrepealable law that some must die in order that others may live. Is there a villain in the piece? Sure. The Barn Owl is a murderer, say we who constantly strive to build a better mousetrap.

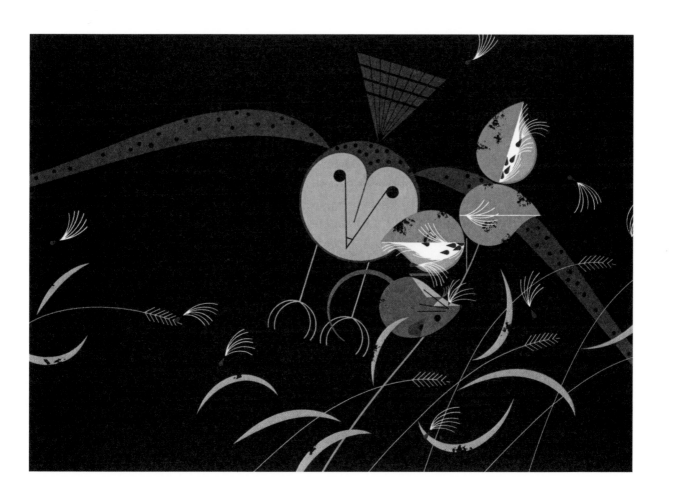

A Family of Chickadees

Young Black-capped Chickadees grow so fast that the generation gap is only a gasp. So in this family portrait it's anybody's guess which ones are the kids. Maybe all of them are. Feeding so many beaks is such a big job that both parents have to work, so they're probably out hustling caterpillars while the kids hang around home, bibs in place, waiting for the groceries to arrive. It's also hard to tell the boys from the girls, unless, of course, you happen to be a Black-capped Chickadee.

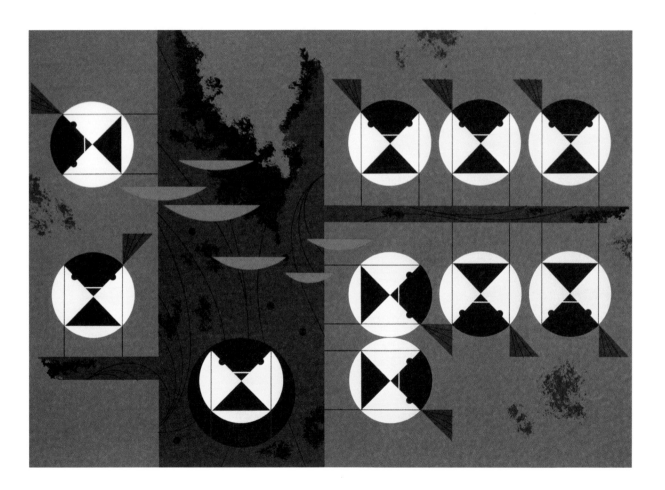

Cardinal

Corn-on-the-cob at ten below and no mittens? No problem. Just tuck your napkin under your chin and have at it. Your first encounter with a Cardinal, adult male, in the snow will rock you with wonder. Startling as a shooting star, unbelievable as thunder on a winter's day, this feathered hyperbole is what you can always say something else is as red as. But nothing else is as.

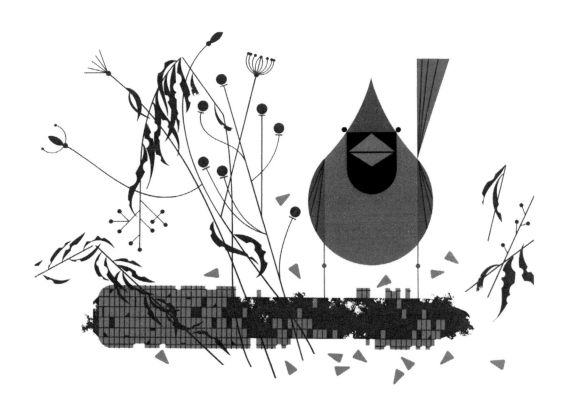

Pileated Woodpecker

Rat-a-tat-tat, slurp, gulp, and that's that. This flying jackhammer will thump a stump to pieces just to snack on carpenter ants, lapping them up with his long flypaper tongue. Or he'll settle for a grubstake of grubs. All in less time that it takes most of us to stumble through his first name. Just remember that it rhymes with how you felt when you added him to your lifetime list—highleated.

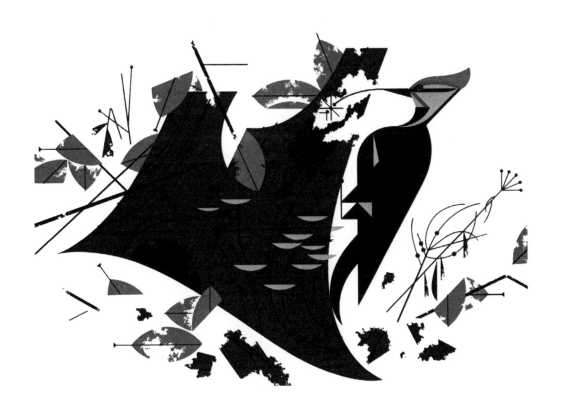

Puffin

If you're like me, you never forget a face, but can't recall the name, so you invent elaborate reminders. Take this funny-looking bird with the false nose, the pasted-on eyebrows, the bright cheek smears — Emmett Kelly with feathers. I have to say to myself: proceeding precipitously, approaching the populous puffinry with ponderous proboscis packed with piscatorial pabulum for the plumping, precocious puffling, he rhymes with muffin. I'll never forget what's-his-name.

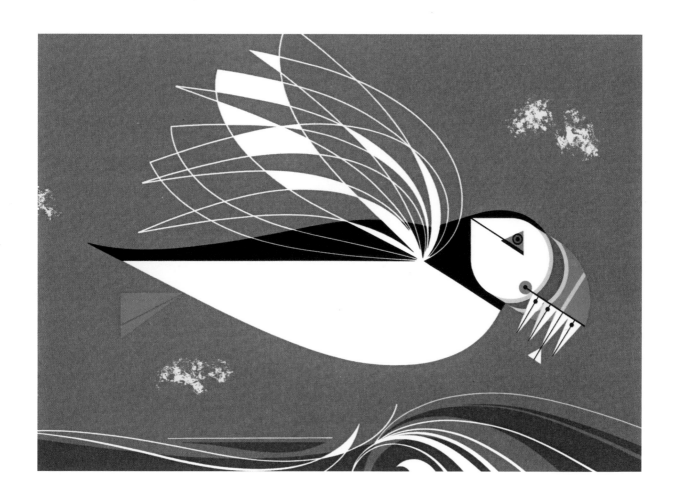

Bluejay Bathing

Here's your friendly neighborhood loudmouth, big on law and order, publishing WANTED posters in stereo. The Blue Jay is always where the action is because he starts it. A roving tomcat snaps a twig, a drowsy owl shifts his weight, a black snake changes his calligraphy — *off* goes the blue-tailed burglar alarm, rounding up a posse for the big chase. But sometimes silence is golden. Like when you're bathing in the brook, naked as a jaybird.

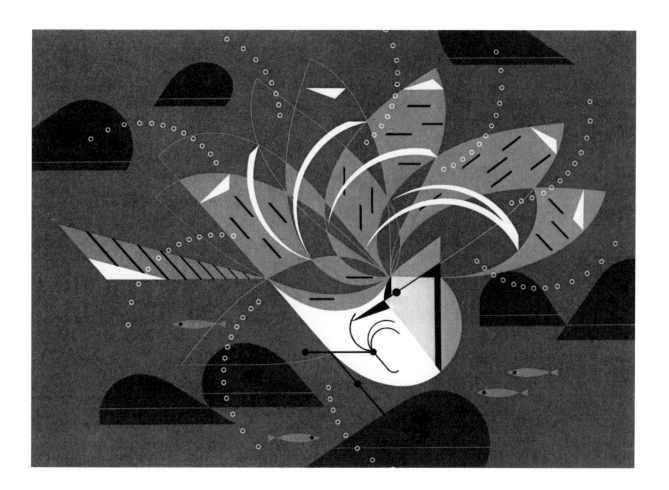

Pelican in a Downpour

If your food is all finned and your chin's double-chinned, you're a Brown Pelican. The seine with a brain. It takes IQ to outwit a mess of menhaden, because they're always in school. By the way, haven't you noticed something fishy about your food lately? Been upset by incomplete incubation? Bad news — you're a vanishing species. DDT. Sorry about that. Nothing personal, though — we meant it for bugs but we didn't stop to . . . Next time we'll plan ahead.

Round Robin

On the leading edge of spring, the cock Robin stakes out his territory and sings up NO TRESPASSING signs. *Cheerily, cheerily, cheerily,* he sings cheerily. Translation: don't light here if you look like me, buster — this backyard's not big enough for both of us. Then the ladies arrive and singles give way to doubles in the annual round robin. With all the fuss and feathers he wins his match and they settle down to perpetuate the species. And that's the name of the game.

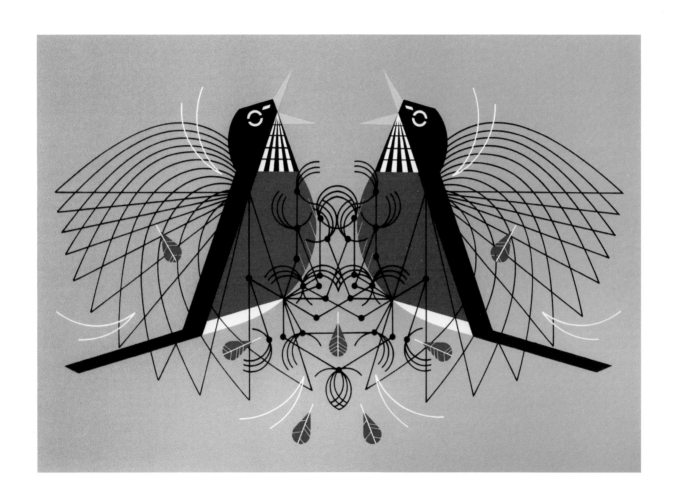

The Last Sunflower Seed

Good cheer is a Cardinal virtue. And what is more cheerful than waking up on a snowy morning to find your backyard full of Cardinals? All that red, white, and who could be blue? Ever wonder why birds of a feather flock together? Maybe because it's easier than flocking apart. Or because that's where the vittles are. Is your bird feeder down to the last sunflower seed? Fill it fast — an empty bird feeder is a Cardinal sin.

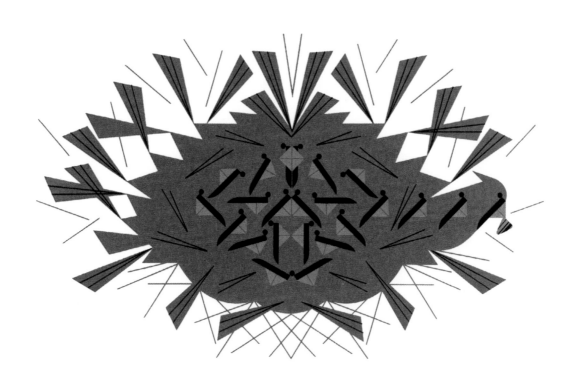

Birds of a Feather

Flocking together as summer wanes, a brigade of bachelor Red-wings swings into the southbound lane, where traffic is backed up to the Arctic Circle. But where are the brownish females? Flocking apart. Red-wing congregations are strictly his and hers, except in spring when they sing I'm *ok-a-lee*, you're *ok-a-lee* and consort among the cattails long enough to make sure there will always be Blackbirds. Then it's back to separate dorms — flocking together apart.

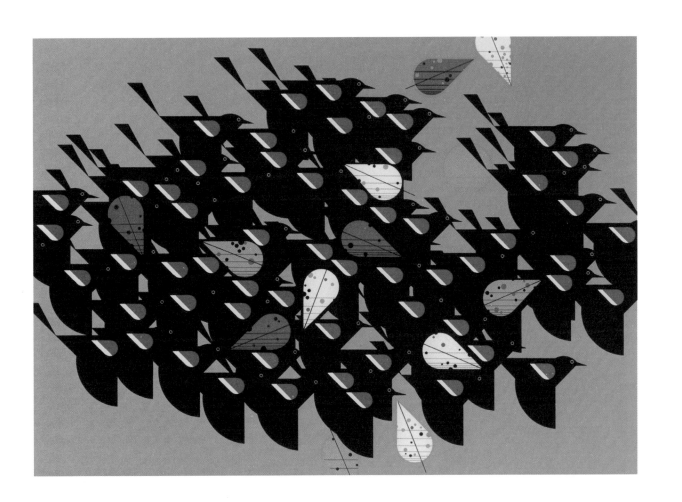

Index